START HERE... FILL THIS PAGE WITH POSITIVE WORDS.

WOO!

AWESOME

UH-HUH!

ONLY MOVE ON ONCE YOU'VE DRAWN AT LEAST 3 WORDS.

THE ART OF GETTING STARTED

LEE CRUTCHLEY

&

———————————

A PERIGEE BOOK

A PERIGEE BOOK
Published by the Penguin Group
Penguin Group (USA)
375 Hudson Street, New York, New York 10014, USA

USA | Canada | UK | Ireland | Australia | New Zealand | India | South Africa | China

Penguin Books Ltd., Registered Offices: 80 Strand, London WC2R 0RL, England
For more information about the Penguin Group, visit penguin.com.

THE ART OF GETTING STARTED

ISBN: 978-0-399-16407-1

First edition: November 2013

PRINTED IN THE UNITED STATES OF AMERICA

10 9 8 7 6 5

While the author has made every effort to provide accurate telephone numbers, Internet addresses,
and other contact information at the time of publication, neither the publisher nor the author
assumes any responsibility for errors, or for changes that occur after publication. Further, the
publisher does not have any control over and does not assume any responsibility for author
or third-party websites or their content.

Most Perigee books are available at special quantity discounts for bulk purchases for sales
promotions, premiums, fund-raising, or educational use. Special books, or book excerpts, can
also be created to fit specific needs. For details, write: Special.Markets@us.penguingroup.com.

ADD YOUR DEDICATION TOO

FOR

MY FAMILY

& FRIENDS (ESPECIALLY MY MOM)

A YEAR FROM NOW
YOU ~~MAY~~ WILL WISH YOU
HAD STARTED TODAY.

KAREN LAMB

FOREWORD

FOR AS LONG AS I CAN REMEMBER I'VE HAD TROUBLE STARTING THINGS. I HAVE GREAT IDEAS AND GOOD INTENTIONS, BUT ACTUALLY COMMITTING TO THAT VERY FIRST STEP MAKES ME NERVOUS. FOR A LONG TIME I DIDN'T REALIZE WHAT I WAS DOING. I'D JUST ENJOY LETTING THE IDEAS SWIM AROUND MY BRAIN WHILE I FOUND OTHER THINGS TO DO.

THE REVELATION CAME WHEN I ACTUALLY ADMITTED WHAT WAS GOING ON. THE TRUTH WAS THAT I WAS SCARED THAT I'D FAIL, OR THAT THE FINAL RESULT WOULDN'T LIVE UP TO THE PROMISE OF THE INITIAL IDEA, OR THAT EVERYONE WOULD LAUGH AT ME. SO I'D DO ANYTHING ELSE I COULD THINK OF. I WAS DELUDING MYSELF THAT THE IDEAS I HAD WERE SO GREAT THAT TURNING THEM INTO REAL THINGS WOULD BE THE EASY BIT.

TURNING IDEAS INTO REAL THINGS IS <u>NOT</u> THE EASY BIT.

IT TAKES WORK, AND DELAYING THE WORK DOES ONE THING — IT DELAYS THE WORK. IT WAS THAT REALIZATION THAT MADE ME START WORKING ON THIS BOOK. THE TASKS INSIDE ARE A COLLECTION OF TECHNIQUES AND TRICKS THAT I'VE COME TO RELY ON WHEN I'M DAUNTED BY THE START OF A PROJECT. THEY WILL HELP TO SHIFT YOUR PERSPECTIVE AND GET YOU EXCITED ABOUT TURNING ALL OF YOUR IDEAS INTO REAL THINGS.

THE GOOD NEWS IS THAT YOU'VE ALREADY DONE THE HARDEST PART. YOU'VE STARTED. YOU'VE FILLED THE FIRST PAGE FULL OF POSITIVE WORDS, YOU'VE SOLVED THE MAZE ON THE COVER, AND YOUR NAME SITS PROUDLY NEXT TO MINE AS CO-AUTHOR.

SO THERE'S NO NEED TO FEAR THE BLANK PAGE...

MASTER *THE ART OF GETTING STARTED!*

THINGS TO REMEMBER:

START EVERY TASK.

IF YOU DON'T LIKE
ONE, START ANOTHER.

DON'T BE AFRAID.

THERE IS NO WRONG.

YOU CANNOT FAIL.

SMILE.

THE WAY
TO GET
STARTED
IS TO QUIT
TALKING
AND START
DOING.

WALT DISNEY

GETTING STARTED

The tasks in this section are designed to be started without thought. Obviously thought and planning are an important part of completing tasks, but we'll get to that later in the book. For now let's get into the habit of starting things without worrying about how they will end.

Procrastinating and avoidance are habits that are easy to slip into, but luckily taking positive and decisive action can also become a habit. Too much thinking is one of the main reasons people put things off, because the more you think about something the more negative thoughts and feelings can become exaggerated.

So approach the next section without any thought — you can't get it wrong or make a mistake, no one will laugh at you for failing, and you'll do just as good a job today as you will tomorrow.

FILL THESE PAGES WITH SCRIBBLES

MAKE SURE NO WORDS REMAIN

CLEAR THE DECKS

- WRITE DOWN <u>EVERYTHING</u> ON YOUR MIND

- TRY TO INDICATE THE SCALE OF EACH THOUGHT

- DON'T WORRY IF THOUGHTS OVERLAP

PHYSICALLY CROSSING TASKS OFF A LIST IS ONE OF THE
BEST WAYS TO CREATE FEELINGS OF ACHIEVEMENT AND
MOTIVATION. CROSS OUT EACH OF THE TASKS BELOW
USING A DIFFERENT PEN. FIND YOUR FAVORITE.

TASK 1

TASK 2

TASK 3

TASK 4

TASK 5

DRAW EVERYTHING

FILL THESE BOXES WITH DRAWINGS OF OBJECTS.
START WITH THE FIRST THING THAT COMES INTO YOUR HEAD,
AND KEEP GOING... DON'T WORRY ABOUT BEING GOOD, JUST DRAW!
IF YOU NEED MORE BOXES, MAKE YOUR OWN AND CLIP THEM IN.
THIS EXERCISE WILL PROVE YOU CAN DRAW ANYTHING!

CHOOSE AN OBJECT YOU JUST DREW AND DRAW IT AGAIN...

WITH YOUR EYES CLOSED

WITH YOUR WEAK HAND

WITH YOUR MOUTH

WITH YOUR FOOT

UPSIDE DOWN

LOOKING IN A MIRROR

IN AN UNUSUAL SETTING

WITH A FACE

SOMETIMES YOU
NEED TO PRESS
PAUSE TO LET
EVERYTHING SINK IN.

SEBASTIAN VETTEL

PAUSE PAGE

GO OUTSIDE FOR 10 MINUTES.
THEN COMPLETE THE NEXT 2 PAGES.

HOW DID THE SKY LOOK?

WHAT WAS THE COLOR PALETTE?

HOW MANY LEAVES
WERE ON THE TREES?

WHAT MADE THAT SOUND?

HOW DID THE GROUND LOOK?

DESCRIBE WHERE YOU WENT IN 3 WORDS.

WHAT WAS MISSING?

HOW DID YOU FEEL?

CONTINUE THE STORY ON THE OPPOSITE PAGE.
DON'T WORRY TOO MUCH ABOUT WHERE THE
STORY IS GOING, OR HOW IT WILL END.
YOUR ONLY CONCERN IS THE FIRST PAGE.
WRITE UNTIL YOU REACH THE BOTTOM.

The night was

SPEND AT LEAST 10 MINUTES
DOODLING ON THESE PAGES
(IT MAY HELP TO TALK ON THE PHONE)

CIRCLE ANY REPEATED DOODLES

TURN THESE BLOBS INTO CREATURES

ADD SOME BLOBS OF YOUR OWN

FILL THESE FRAMES COMPLETELY WITH PENCIL

USE AN ERASER TO DRAW SOME PICTURES

DRAW ON BOTH THESE

HERE WITH YOUR LEFT HAND

PAGES AT THE SAME TIME

HERE WITH YOUR RIGHT HAND

OVER THESE PAGES
IN DOODLES OF ARROWS

IF YOU EVER FEEL COMPLETELY DAUNTED BY
THE START OF A NEW TASK, IT'S A GOOD IDEA
TO TAKE YOUR MIND OFF IT FOR A WHILE.

CLOSE YOUR EYES AND CHOOSE A RANDOM
TASK FROM THE LIST OPPOSITE.

IMAGINE IT'S THE MOST IMPORTANT ITEM ON
YOUR TO-DO LIST.

APPROACH IT WITH EVERYTHING YOU'VE GOT.

WATCH TV ON MUTE IMAGINE THE WORDS	DANCE
READ ABOUT A SUBJECT YOU KNOW NOTHING ABOUT	EAT COOKIES (OR SIMILAR)
RIDE A BIKE	PLAN YOUR WEEKEND LEISURE TIME
CLEAN SOMETHING	TAKE A BATH (OR SHOWER)
PRACTICE SPEAKING IN A FOREIGN ACCENT	GO FOR A WALK

USE 3 COLORS TO TURN THESE

DOTTED GRIDS INTO PATTERNS

THE CORE OF MAN'S SPIRIT COMES FROM NEW EXPERIENCES.

CHRISTOPHER McCANDLESS

PANIC PAGE!

GO SOMEWHERE THAT
YOU'VE NEVER BEEN.

THE FURTHER AWAY THE BETTER.

GO THERE TODAY.

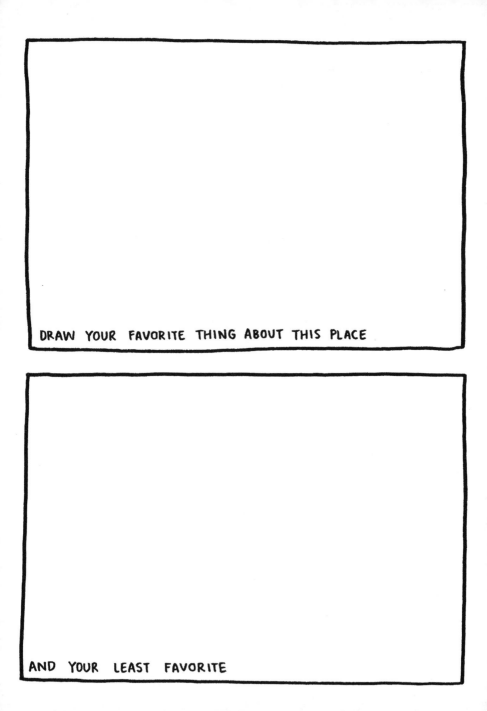

DRAW YOUR FAVORITE THING ABOUT THIS PLACE

AND YOUR LEAST FAVORITE

MAKE UP A CONVINCING LIE ABOUT WHERE YOU'VE BEEN.
BE AS DETAILED AS YOU CAN.

MAKE SURE THAT

EVERYONE'S HAPPY

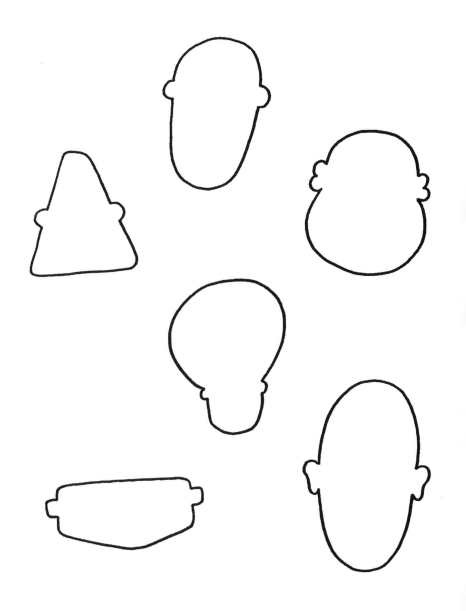

DRAW EVERY SHAPE

YOU CAN THINK OF

THEN TRY TO NAME THEM ALL

CHOOSE A 1-INCH DETAIL OF SOMETHING IN FRONT OF YOU
AND DRAW IT IN THE SQUARE BELOW. TRY TO CHOOSE
AN AREA WITH AS MUCH DETAIL AS POSSIBLE.

RE-CREATE THE SQUARE USING AS MANY DIFFERENT MATERIALS
AND TECHNIQUES AS YOU CAN THINK OF.

IDEAS: PAINT
 COLLAGE
 THE WRONG COLORS
 CHARCOAL
 CROSS HATCHING
 POTATO PRINTING
 WAX
 FINGER PAINTING
 ETC.

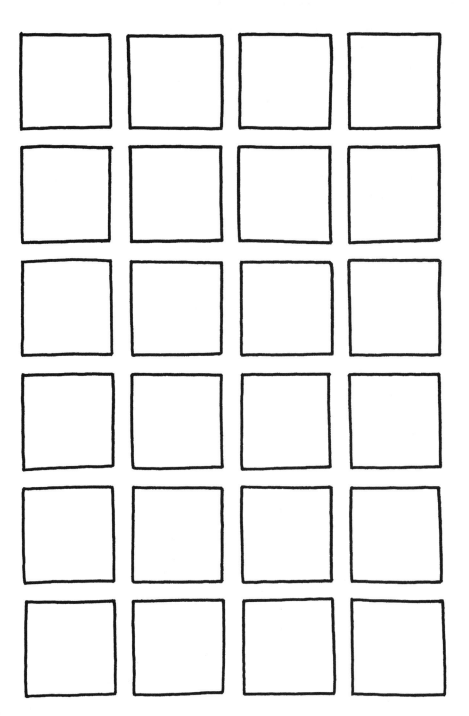

DRAW YOURSELF USING YOUR FAVORITE OF THE TECHNIQUES YOU JUST USED

DO THE SAME WITH YOUR LEAST FAVORITE

ARRANGE A COLLECTION OF OBJECTS IN FRONT OF YOU.

DRAW ONLY THEIR SHADOWS.

I CAN ACCEPT
FAILURE,
EVERYONE
FAILS AT
SOMETHING.
BUT I CAN'T
ACCEPT NOT
TRYING.

MICHAEL JORDAN

WHAT'S STOPPING YOU?

There are always a million reasons to stop you from doing something: fear of failure, not knowing what's expected of you, thinking a task is too hard, not feeling like it, the list goes on.

It's important to identify the things that are specifically holding you back. There's a chance that at the moment you're unaware of the reasons why you're putting something off or procrastinating.

These tasks will help you figure out exactly what's stopping you. As soon as you've identified those things it will be much easier to make positive changes and avoid falling into the same habits.

PROCRASTINATION LOG

EVERY TIME YOU PROCRASTINATE WHILE WORKING THROUGH THIS BOOK COME BACK AND RECORD IT HERE. DRAW YOUR TV, WRITE OUT YOUR TWEETS, TALLY UP THE MINUTES YOU STARE INTO SPACE...

YOU SHOULD NOTICE PATTERNS START TO FORM. THIS WILL HELP YOU TO IDENTIFY THE MAIN OFFENDERS AND MAKE CHANGES.

TIP: FOLD CORNERS
TO BOOKMARK PAGES

CAN'T
IS THE
REAL
"C-WORD."

MARTY HUGGINS

PANIC PAGE!

CHOOSE SOMETHING YOU "CAN'T DRAW":

SOMETHING YOU HATE DRAWING.

SOMETHING YOU WOULDN'T WANT TO DRAW EVEN IF I PAID YOU.

...DRAW IT OVER AND OVER
UNTIL THESE PAGES ARE COVERED.

QUICKLY LIST 5 THINGS
YOU'VE BEEN AVOIDING

1:

2:

3:

4:

5:

CHOOSE ONE AND DO IT NOW!

(DRAW HOW IT MADE YOU FEEL)

WRITE OR DRAW YOUR FEARS

THEN SCRIBBLE THEM <u>ALL</u> OUT

THINK OF 2 THINGS YOU ACHIEVED IN THE LAST YEAR. DESIGN AWARDS FOR THEM.

DRAW YOUR FAVORITE OBJECT AS IF YOU WERE AN ANT

DRAW IT AS IF YOU WERE AN EAGLE IN FLIGHT

INTERVIEW AT LEAST 1 OF THE PEOPLE LISTED BELOW:

- ☐ A CHILD
- ☐ A COMPLETE STRANGER
- ☐ ONE OF YOUR PARENTS
- ☐ A FRIEND
- ☐ SOMEONE WHO LIVES ABROAD

ASK THEM AT LEAST THESE 5 QUESTIONS:

1) WHAT DO YOU WANT FROM LIFE?
2) HOW DO YOU FEEL ABOUT THE FUTURE
3) HOW ABOUT THE PAST?
4) WHEN ARE YOU HAPPIEST?
5) WHAT WOULD YOU DO NEXT IF YOU WERE ME?

(FEEL FREE TO ASK MORE OF YOUR OWN.)

RECORD THEIR ANSWERS...

CLIP IN MORE PAPER IF YOU NEED TO.

INVENT A TOOL
THAT COULD SOLVE
ALL YOUR PROBLEMS.

DRAW OR COLLAGE IT.

DESCRIBE ITS FEATURES.

DON'T FORGET TO GIVE
IT A NAME.

THINK OF SOMETHING THAT'S MADE UP OF MANY
COMPONENT PARTS: A TV, A BICYCLE, A MEAL...
WRITE OR DRAW IT IN THE SPACE BELOW.

DRAW OR LIST EVERY COMPONENT YOU CAN THINK
OF THAT MAKES UP THIS OBJECT.

PEOPLE OFTEN SAY THAT
MOTIVATION DOESN'T LAST.
WELL, NEITHER DOES
BATHING - THAT'S WHY WE
RECOMMEND IT DAILY.

ZIG ZIGLAR

PAUSE PAGE

THINK ABOUT SOMETHING YOU
NEED TO CLEAN OR ORGANIZE.

YOUR CAR? YOUR DESK? YOURSELF?

DRAW IT IN AS MUCH DETAIL AS POSSIBLE.

MAKE SURE YOU CAPTURE ALL THE DIRT OR MESS.

WHEW. THAT WAS HARD WORK, WASN'T IT?

NOW IT'S TIME TO CLEAN IT...

TAKE IT ON THE ROAD...

COMPLETE THE NEXT 4 TASKS IN DIFFERENT PLACES.
IT COULD BE A PARK, A COFFEE SHOP, THE BATH...
ANYWHERE BUT YOUR DESK!

COLLECT A SOUVENIR FROM EACH PLACE ON THE OPPOSITE PAGE.

1 _____

2 _____

3 _____

4 _____

THIS IS A RANDOM LINE DRAWN BY ME,
WHICH IS A STARTING POINT FOR YOU.

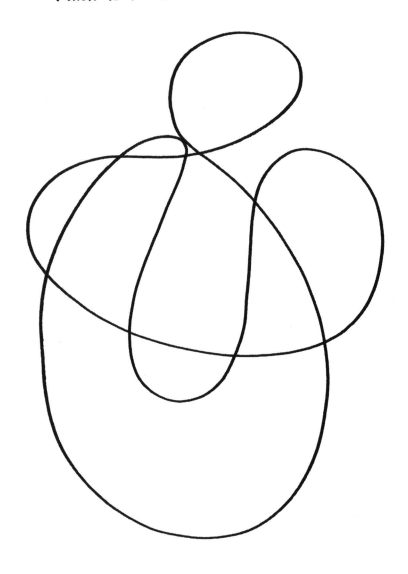

ADD SOME DETAILS TO MAKE A PICTURE.
THINK ABOUT FACES, ANIMALS, PATTERNS,
WHATEVER COMES INTO YOUR MIND.

MAKE YOUR OWN RANDOM LINE DRAWING.

WHAT WOULD YOU DO IF MONEY WERE NO OBJECT?

LIST 3 THEMES YOU NOTICE
IN WHAT YOU WROTE.

MINE ARE: TRAVEL, ART, EAT.

IT HELPS TO MAKE THEM
BIG AND COLORFUL.

1:

2:

3:

TOMORROW IS OFTEN THE BUSIEST DAY OF THE WEEK.

SPANISH PROVERB

PANIC PAGE!

STOP SAYING
"I'LL DO IT TOMORROW."
THERE IS ONLY EVER TODAY.

→

DRAW THE WORD TODAY AS MANY TIMES AS YOU CAN.

TODAY

TODAY

tOdAy

USE DIFFERENT STYLES, COLORS, AND SIZES.

FORCE YOURSELF TO DO NOTHING
FOR AS LONG AS POSSIBLE.

NO TV.
NO INTERNET.
NO THINKING.

DO NOTHING AT ALL.

IT'S NOT AS FUN AS YOU IMAGINE.

WRITE HOW LONG YOU MANAGED
IN THE WHITE CIRCLE OPPOSITE.

STARE INTO THE CIRCLE IF YOUR MIND STARTS TO WANDER.

TAKE A RISK

IT'S NEVER AS BAD AS YOU IMAGINE

TALK TO STRANGERS	EAT SOMETHING UNKNOWN TO YOU
PERFORM AT AN OPEN MIC NIGHT	CONFESS TO SOMETHING
JUMP	ASK A STRANGER OUT ON A DATE
RECALL YOUR MOST EMBARRASSING MEMORY	TELL SOMEONE A SECRET
MAKE A NEW FRIEND	TRY OUT FOR A SPORTS TEAM

LIST ALL OF YOUR SHORTCOMINGS ON THIS PAGE

NOW SCRIBBLE OUT THIS LIST

LIST THE OPPOSITE OF EACH ON THIS PAGE

TRY TO BE MORE LIKE THIS LIST

DETENTION: CONTINUE THE LINES TO FILL THESE PAGES.

I WILL NO LONGER PROCRASTINATE.
I WILL NO LONGER PROCRASTINATE.

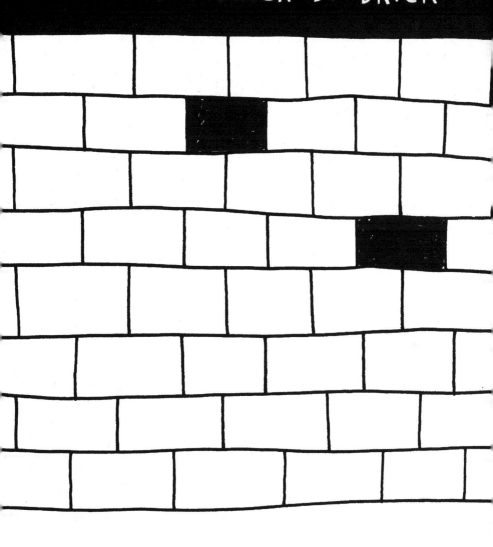

USE YOUR PEN TO SCRIBBLE
IT DOWN — BRICK BY BRICK

THE BEST THING
YOU CAN DO IS
THE RIGHT THING.
THE NEXT BEST
THING IS THE
WRONG THING,
AND THE WORST
THING IS NOTHING.

THEODORE ROOSEVELT

WHERE ARE YOU HEADING?

By now you should be fully into the "getting started" frame of mind. You'll be used to starting things without fear, and you'll have an idea of what has been holding you back in the past.

The final tricky obstacle is the end goal. You'll never be able to start your journey if you don't know where you're heading. But sometimes the end goal can seem so huge and daunting that it stops you from taking the first step altogether.

These tasks will show you that there are plenty of things you can do to relieve that fear. You can break the goal down into smaller chunks, approach it from unusual angles, try new ways of working, etc. etc.

There are hundreds of ways to reach your goals. But the most important thing is always the next step.

WHERE ARE YOU HEADING?
IS IT A PLACE?
OR A FEELING?
OR A LIFELONG DREAM?

WELCOME TO

DRAW IT ON THE HORIZON

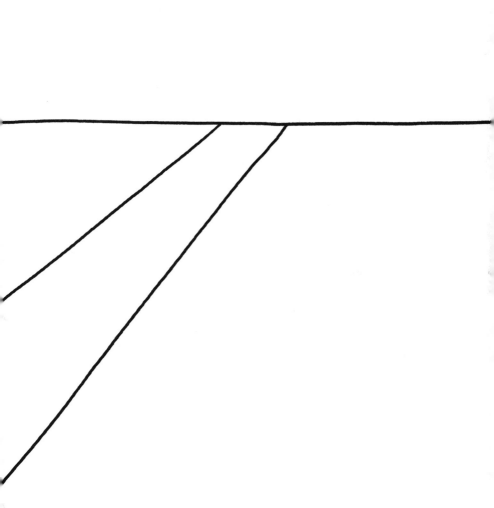

YOU CAN'T PUT
YOUR FEET ON
THE GROUND
UNTIL YOU'VE
TOUCHED THE SKY.

PAUL AUSTER

PAUSE PAGE

LOOK UP AT THE SKY.
LET YOURSELF DAYDREAM.
MOVE ON WHEN YOU FEEL READY.

DRAW OUTLINES OF ALL THE CLOUDS.
IF THERE ARE NONE IMAGINE SOME.

TURN THOSE CLOUDS INTO ANIMALS (OR MONSTERS).

COOK A MEAL YOU'VE NEVER EATEN BEFORE

DRAW THE INGREDIENTS

DESCRIBE THE MEAL IN DETAIL...

WHICH WAY DID YOUR ARROWS POINT EARLIER?

DOODLING ARROWS REPRESENTS AMBITION. IF YOUR ARROWS
POINTED IN DIFFERENT DIRECTIONS IT SUGGESTS YOU HAVE
PLENTY OF IDEAS BUT ARE LACKING FOCUS.

FILL THESE PAGES WITH MORE ARROWS. THIS TIME MAKE SURE
THEY ALL POINT IN THE SAME DIRECTION. IF YOURS ALREADY
DID, TRY IT THE OTHER WAY AROUND. HOW DOES IT FEEL?

THIS IS THE BEGINNING OF A MIND MAP WITH THE
WORD "START" AT THE CENTER.

THE IDEA OF THIS MAP IS TO EXPLORE RELATED
WORDS ON BRANCHES AWAY FROM THE CENTER.

KEEP ADDING TO THIS MIND MAP UNTIL THE PAGES
ARE FULL OR YOUR MIND IS BLANK.

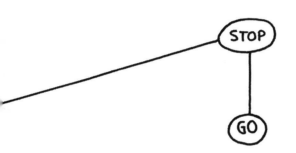

IMAGINE YOU ARE YOUR FAVORITE TV CHARACTER... REALLY BELIEVE IT.

WHAT IS YOUR FAVORITE FOOD?

WHAT IS YOUR FAVORITE OBJECT?

WHERE IS YOUR FAVORITE PLACE?

WHO IS YOUR FAVORITE PERSON?

IMAGINE THAT GETTING STARTED ON A TASK IS CELEBRATED
WITH A HUGE CONGRATULATORY PARTY.

DESIGN A GREETING CARD FOR THE OCCASION.

7: THAT'S BETTER
●

3: UH-HUH
●

1 ●

2: OK
●

● 4: THIS IS GOOD

A ●——

●
6: NO!

●
5: WAIT

●
8: YES!

THE BLACK LINE REPRESENTS HOW WE THINK WE'LL GET FROM A TO B.
CONNECT THE NUMBERED DOTS TO SEE HOW WE REALLY GET THERE...

● 11: NICE

9: AWESOME!
●

12: HMMM
●

●
10: KIND OF

● 13: ALL RIGHT!

16: I SUCK!
●

20: I'M AWESOME!
●

———————————————————————————————●B

●
15: THIS SUCKS!

18: FORGET IT
●

●
14: ARGHHH!

●
17: EVERYTHING SUCKS!

●
19: HANG ON...

IF YOU WANT
YOUR LIFE TO BE
A MAGNIFICENT
STORY, THEN BEGIN
BY REALIZING
THAT YOU ARE
THE AUTHOR.

MARK HOULAHAN

PANIC PAGE!

TELL YOUR LIFE STORY.

DON'T WORRY ABOUT SPELLING
OR THE ORDER OF MEMORIES.

JUST WRITE...

STOP HERE FOR NOW. CONTINUE WHENEVER YOU FEEL LIKE IT.

OPEN A RANDOM BOOK TO A RANDOM PAGE AND CHOOSE
A RANDOM SENTENCE. WRITE IT IN SLOT 1 BELOW.
DO THE SAME WITH A DIFFERENT RANDOM BOOK AND
WRITE IT IN SLOT 2.

THESE WILL BE THE FIRST AND LAST SENTENCES OF YOUR
SHORT STORY. WRITE THAT STORY ON THE OPPOSITE PAGE.

1: _____

2: _____

DRAW YOUR PAST

DRAW YOUR FUTURE

DRAW YOUR CURRENT BUSINESS CARD.
IF YOU DON'T HAVE ONE, IMAGINE YOU DO.

DRAW YOUR BUSINESS CARD
5 PERFECT YEARS FROM NOW.

PICK A RANDOM ADVERTISEMENT FROM A NEWSPAPER
OR MAGAZINE AND STICK IT HERE.

NOW MAKE YOUR OWN VERSION OF THE SAME AD.
WHAT WOULD YOU DO DIFFERENTLY?

IMAGINE YOU ARE 9 YEARS OLD AGAIN.

THINK ABOUT YOUR DREAM HOUSE.

WHERE IS IT? IN A TREE? IN SPACE? UNDERGROUND?

WHAT FEATURES DOES IT HAVE? A SLIDE? A MOAT? LASERS?

DRAW IT ON THIS PAGE

DRAW YOURSELF

10 SECONDS 30 SECONDS

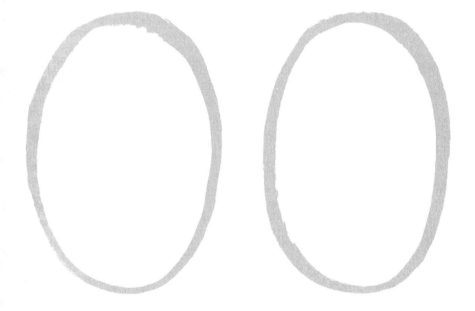

SPEND **EXACTLY** THIS AMOUNT OF TIME

4 TIMES (TIMED)

1 MINUTE

5 MINUTES

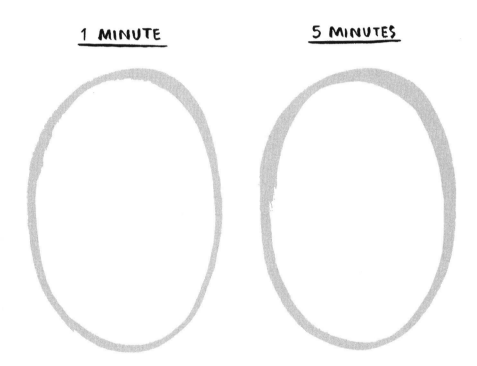

ON EACH DRAWING. NO MORE. NO LESS.

CUT **5** RANDOM HEADLINES FROM A News PAPER & USE THEM TO WRITE a POEM

REMEMBER THAT STORY YOU STARTED?
CONTINUE IT FOR ONE MORE PAGE.

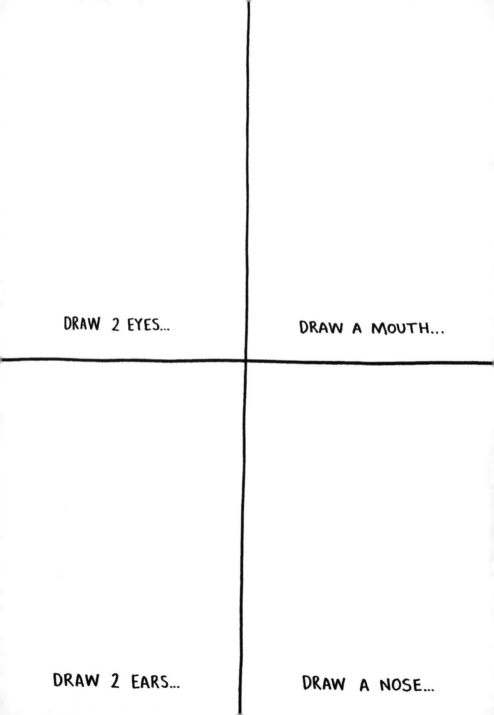

DRAW 2 EYES...

DRAW A MOUTH...

DRAW 2 EARS...

DRAW A NOSE...

NOW DRAW THEM ALL AND MAKE A FACE.

LOOK AT THE MOST INTERESTING OBJECT IN FRONT OF
YOU FOR 10 SECONDS. NOW DRAW IT IN AS MUCH DETAIL
AS POSSIBLE WITHOUT TAKING YOUR EYES OFF THIS PAGE.

DRAW IT AGAIN WITHOUT TAKING YOUR EYES OFF THE OBJECT. ONCE YOU START DRAWING DON'T LOOK AT THE PAGE AGAIN UNTIL YOU'RE DONE.

DRAW THE VIEW

FROM UNDER YOUR DESK

FROM A MOVING CAR (NOT ONE YOU'RE DRIVING)

LOOKING DOWN FROM A WINDOW

INSIDE YOUR FRIDGE

THE FUTURE
YOU SEE
IS THE FUTURE
YOU GET.

ROBERT G ALLEN

PAUSE PAGE

THINK ABOUT EVERYTHING YOU
WANT TO ACHIEVE IN LIFE.
THEN WRITE IT ALL DOWN...

THE BUCKET LIST

LIST EVERYTHING YOU WANT TO ACHIEVE BEFORE YOU "KICK THE BUCKET".

INCLUDE ANY THAT YOU'VE ALREADY ACHIEVED AND CROSS THEM OFF. THINK BIG.

ABOUT THE AUTHOR

LEE CRUTCHLEY IS AN ARTIST AND AUTHOR FROM A SMALL TOWN IN ENGLAND. HE HAS WRITTEN THREE BOOKS. HIS LATEST IS *HOW TO BE HAPPY (OR AT LEAST LESS SAD)*.

HE HAS A WEBSITE: LEECRUTCHLEY.COM

ACKNOWLEDGMENTS

THANKS TO MY FAMILY AND FRIENDS, ESPECIALLY MY MOM AND PAUL, WHOSE SUPPORT HAS ENABLED ME TO DO THE THINGS I LOVE TO DO.

THANKS TO THE WHOLE TEAM AT PERIGEE FOR BELIEVING IN THIS BOOK. AND A VERY SPECIAL THANKS TO MY EDITOR, MARIAN LIZZI, WHOSE IDEAS AND PATIENCE MADE THIS BOOK BETTER THAN I COULD HAVE MADE IT ALONE.

ADD YOUR OWN BIO AND ACKNOWLEDGMENTS.

YOU DID IT! THAT WAS EASY, RIGHT?

IF EVERYTHING WENT TO PLAN YOU'VE STARTED THINGS WITHOUT WORRYING ABOUT THE FINAL OUTCOME, YOU'VE WORKED OUT THE THINGS THAT HAVE BEEN STOPPING YOU IN THE PAST, AND YOU'VE SEEN THAT THERE ARE LIMITLESS WAYS TO REACH YOUR GOALS.

YOU'LL HAVE LOVED SOME OF THE TASKS AND I'M SURE YOU'LL HAVE HATED OTHERS. NOW YOU'RE HERE AND HOPEFULLY EXCITED TO START YOUR NEXT BIG (OR SMALL) PROJECT. THE MOST IMPORTANT THING TO REMEMBER IS THAT GETTING STARTED IS HABITUAL, THE SAME AS PROCRASTINATING AND AVOIDANCE. IT'S IMPORTANT TO KEEP PRACTICING THE TECHNIQUES THAT HAVE WORKED BEST FOR YOU AND TO REMEMBER ALL THOSE LITTLE REVELATIONS YOU HAD ALONG THE WAY.

I WROTE MYSELF A FEW RULES TO REMEMBER WHENEVER I'M FACED WITH THAT DREADED FIRST BLANK PAGE.

1: DON'T BE AFRAID TO FAIL.

2: ADMIT WHEN YOU'RE PROCRASTINATING.

3: PROCRASTINATION KILLS FREE TIME.

4: SEVERAL SMALL GOALS ARE BETTER THAN ONE HUGE ONE.

5: DOING ANYTHING IS BETTER THAN DOING NOTHING.

6: THE SOONER YOU TAKE THE FIRST STEP
 THE SOONER YOU CAN START WALKING.

7: TODAY WAS TOMORROW YESTERDAY.

MAKE YOUR OWN "RULES FOR GETTING STARTED" LIST OR POSTER ON THE OPPOSITE PAGE. STICK IT UP IN YOUR WORK SPACE AND REFER TO IT EVERY TIME YOU FEEL YOURSELF AVOIDING THAT FIRST STEP. IN NO TIME YOU'LL BE STARTING THINGS BEFORE YOU'VE HAD THE CHANCE NOT TO.

THE ACHIEVEMENT OF ONE GOAL SHOULD
BE THE STARTING POINT OF ANOTHER.

ALEXANDER GRAHAM BELL